Ginny Ruffner

Reforestation of the Imagination

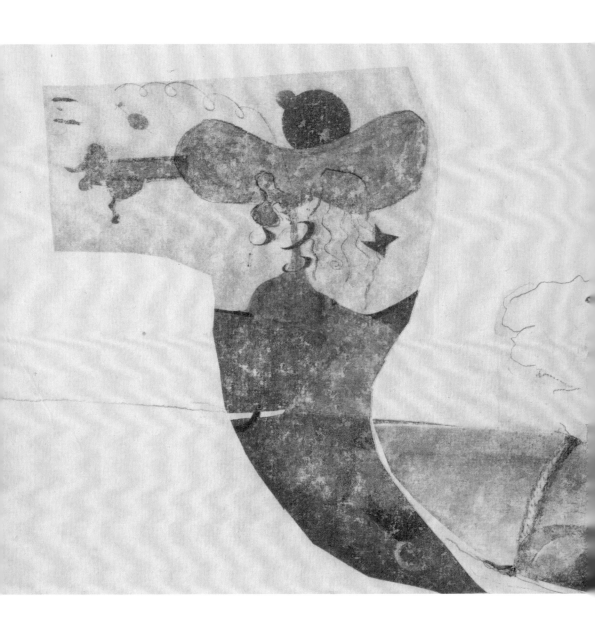

Ginny Ruffner

Reforestation of the Imagination

Ginny Ruffner with Grant Kirkpatrick

Renwick Gallery of the
Smithsonian American Art Museum
Washington, DC

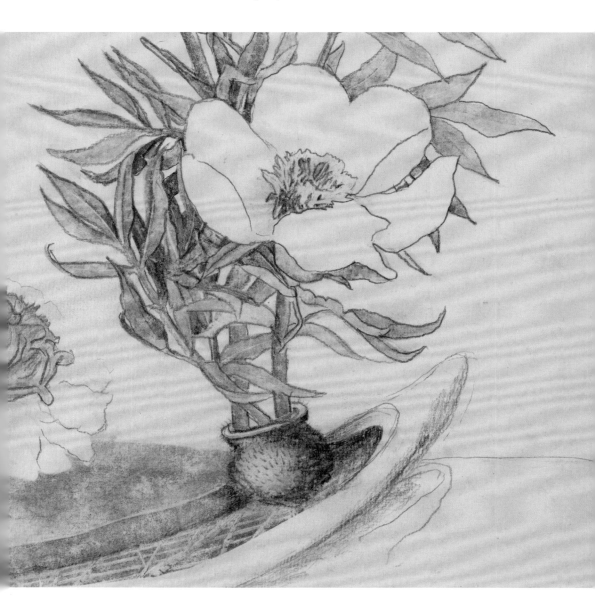

Ginny Ruffner

Reforestation of the Imagination

is organized by the Renwick
Gallery of the Smithsonian
American Art Museum.
Generous support has been
provided by:

The Smithsonian American
Women's History Initiative

Elizabeth and James Eisenstein

Ed and Kathy Fries

Shelby and Frederick Gans

James Renwick Alliance

Colleen and John Kotelly

Betty and Whitney MacMillan

Jacqueline B. Mars

Kim and Jon Shirley Foundation

Myra and Harold Weiss

Contents

Artist's Note

Reforestation of the Imagination combines traditional sculpture with augmented reality (AR). By using technology to overlay digital information onto sculptural objects, two disparate environments are portrayed.

The setting is an apocalyptic landscape far in the future. The initial environment consists of five landmasses, which support the glass stumps. Except for the painted shelf mushrooms and tree rings on the stumps and logs, the scene is colorless. The landmasses surround a sixth rocky outcropping that features a large fiberglass stump. The central stump sprouts beautifully grotesque bronze, then glass appendages. This improbable growth has survived the devastation to create a new botany.

Other than the central stump, the landscape appears at first glance to be barren. Yet, upon viewing the tree rings aided by AR technology, a second environment is revealed. Plants appear (both fruit and flowers), which have evolved from existing flora. They have developed dramatic appendages and the skills necessary to adapt and flourish in this radically different environment. From accessing nutrients in ways that symbiotically improve their surrounding conditions, to cultivating protections from new threats, these adaptations are unexpected, beautiful, and optimistic. This is nature reimagining itself. The imagination cannot be exterminated. It just re-creates itself.

GR

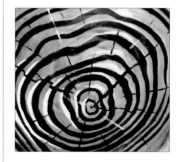

This book features holographic images that can be activated through your phone's camera. Simply follow these instructions to bring this augmented reality to life.

—

Download the free app *Reforestation*; follow the prompts

—

With the app open, point the camera-phone at the tree-ring detail shown on the flower description pages

—

Watch the hologram appear on your camera screen

Map

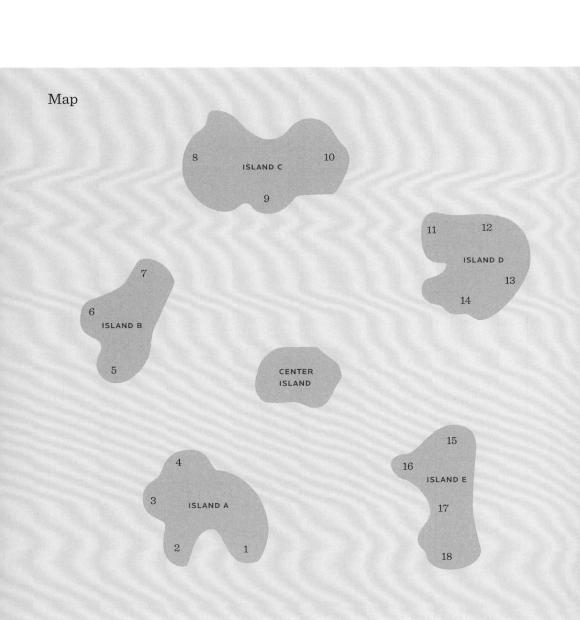

Field Guide to the
NEW Wildflowers of the Mind

In her imagined landscape, the artist uses playful takes on Latin words as naming conventions for her wildflowers.

ISLAND A

1. *Liriodendrum plausus* (Flapping tulip)

2. *Anthurium vinifera* (Grape flower)

3. *Taraxacum genu varum* (Dandelion carrot)

4. *Serpens primula nubes* (Blue flower with snakes)

ISLAND B

5. *Pyrus fenestrata* (Pear with windows)

6. *Ventus ingenero* (Windmill flower)

7. *Canna grandiflora* (Magnolia gondola)

ISLAND C

8. *Cibus devoradum* (Carnivorous pitcher plant)

9. *Digitalis artherium* (Double art flowers)

10. *Lacertus vespertilio* (Flapping lizard bat flower)

ISLAND D

11. *Musa saponifica* (Soapy muse)

12. *Picus germinabunt* (Woodpecker flower)

13. *Scandent vinea clayaria* (Morning glory with Paul Klee leaf)

14. *Tulipia kandinskiana torquem* (Kandinsky tulip)

ISLAND E

15. *Avem iridis illuricae* (Hummingbird flower)

16. *Astromaria zentada lillium* (Blue/purple flowering vine)

17. *Navis tabula senex* (Connect the dots flower)

18. *Rosa cilliabunda* (Rose with eyelashes)

CENTER ISLAND

Bronze Tree

Liriodendrum plausus

Flapping tulip

NAMING CONVENTIONS

Liriodendrum = tulip
plausus = flapping

DESCRIPTION

Liriodendrum plausus is a lovely specimen, thought to have evolved from an ancient twenty-first-century animal and plant gene—sharing experiment. Originally hybridized in an attempt to increase stem flexibility for the tulip industry, it subsequently evolved very active and flexible foliage.

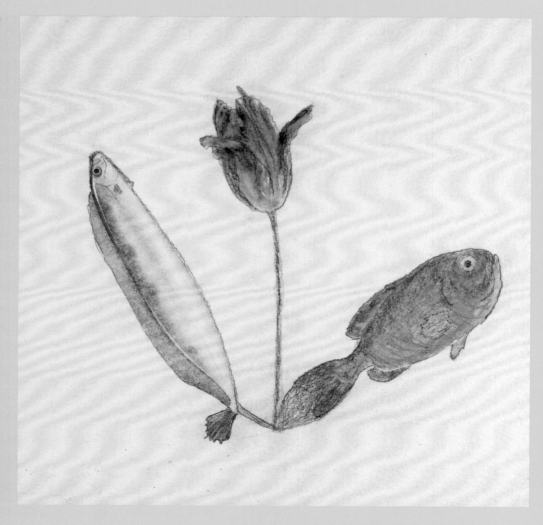

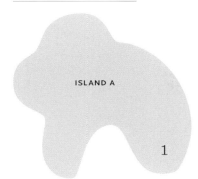

ISLAND A

1

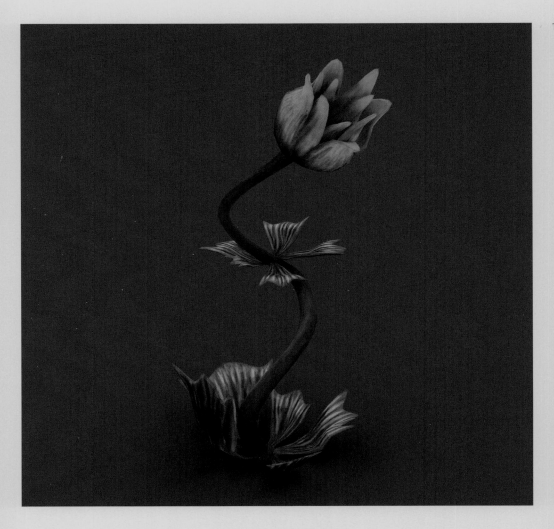

Anthurium vinifera

Grape flower

Anthurium = phallic flower
vinifera = grapes

DESCRIPTION

Anthurium vinifera is typically cultivated in semiarid rolling hills and was first discovered in vineyards. Scientists do not know when or how the *Anthurium vinifera* evolved from traditional grape cultivars into this unusual varietal, which produces a grape-colored vessel that encases and protects each fruit cluster.

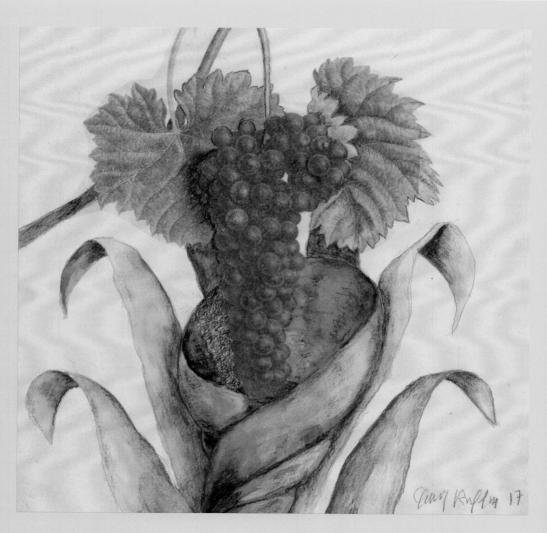

LOCATION

ISLAND A

2

TARGET

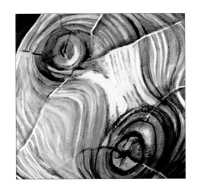

13

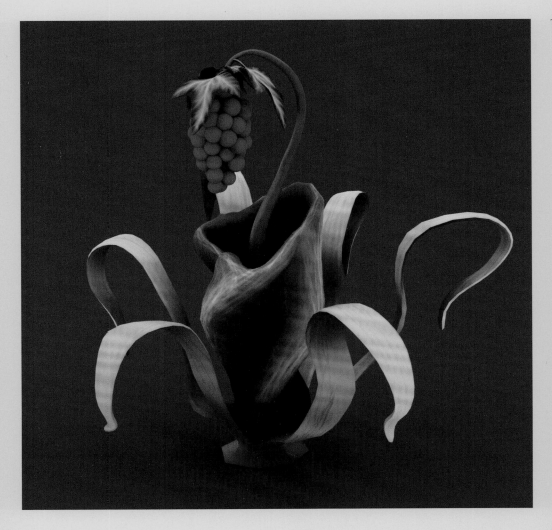

Taraxacum genu varum

Dandelion carrot

NAMING CONVENTIONS

Taraxacum = dandelion
genu varum = knee

DESCRIPTION

Taraxacum genu varum is usually found in the arid, windswept, moderately hilly and formerly abundant environments known as prairies. Identifiable by its short hard trunk and shallow claw-shaped root, the *Taraxacum genu varum*'s pink springtime blossom perches atop a cactus-like seasonal growth.

The seeds, produced by its tassel-shaped flower parts, are wind pollinated.

14

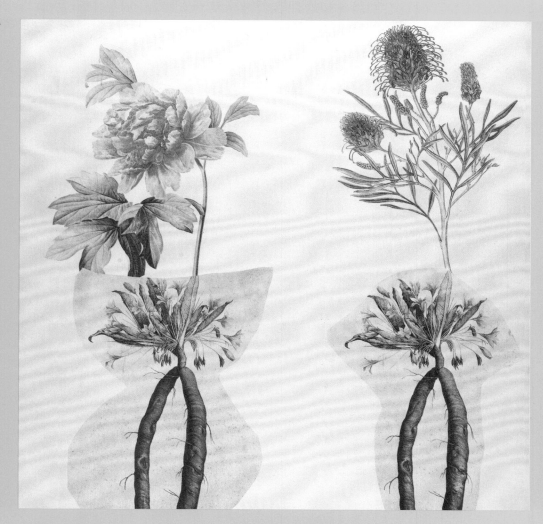

3 ISLAND A

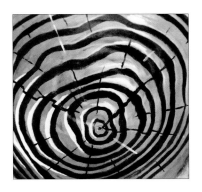

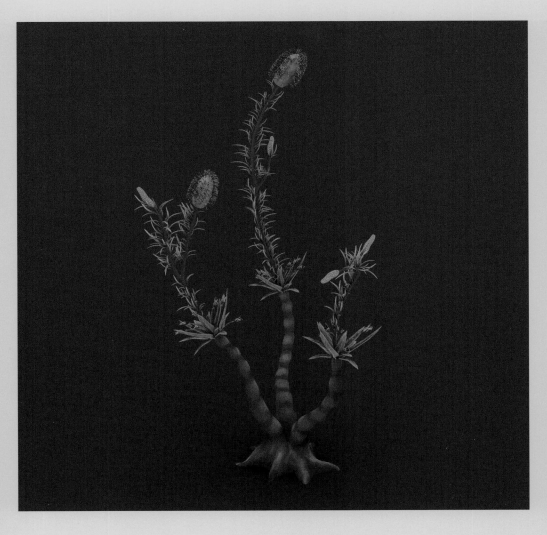

15

Serpens primula nubes

Blue flower with snakes

NAMING CONVENTIONS

Serpens = snakes
primula = daisy
nubes = cloud

DESCRIPTION

Serpens primula nubes produces two distinct flowers. Protruding from openings in the bulbous woody stalk, the uppermost blossom is usually yellow. The lower blossoms, typically blue, develop pistils, which wriggle energetically in the presence of avian predators. After being ingested, these pollen-covered worm-like appendages are digested and subsequently scattered via bird droppings.

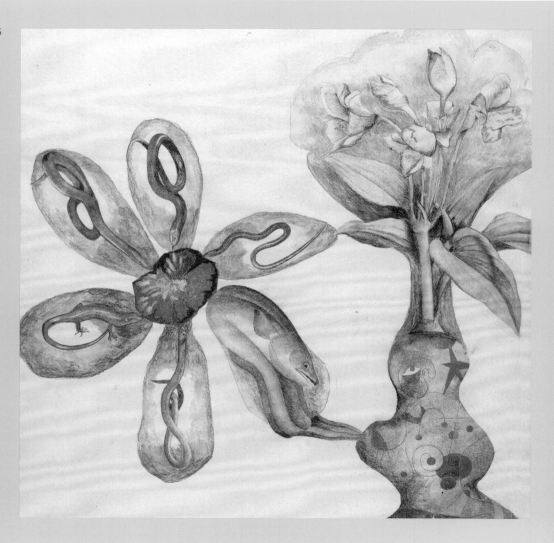

4

ISLAND A

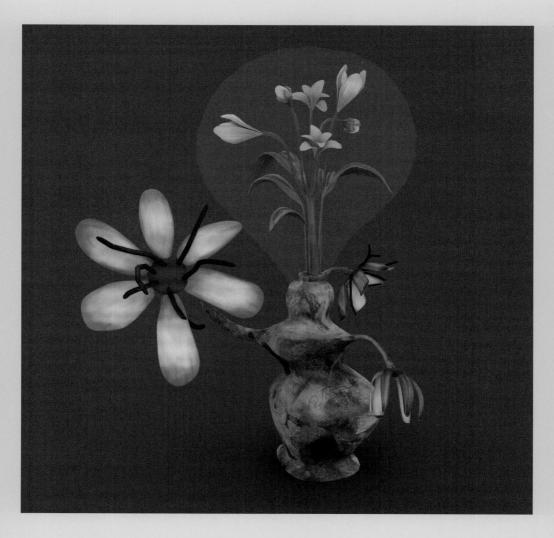

Pyrus fenestrata

Pear with windows

Pyrus = pear
fenestrata = windows

DESCRIPTION

Pyrus fenestrata is common in the formerly deciduous woods of the Eastern Seaboard. The evolution of its inhabitable fruit is thought to have been a means of protecting its major pollinator, a small bee that uses it as a resting station between pollen-gathering journeys. The edible pear-shaped fruit produces transparent waxy apertures that also guard against predators, causing them to flee upon seeing their own reflection in the "windows." The plant produces a fragrant pale yellow blossom in the spring and bears fruit year-round.

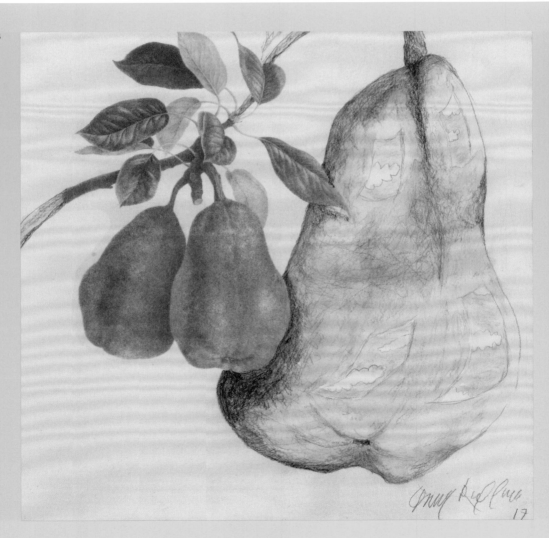

17

ISLAND B

5

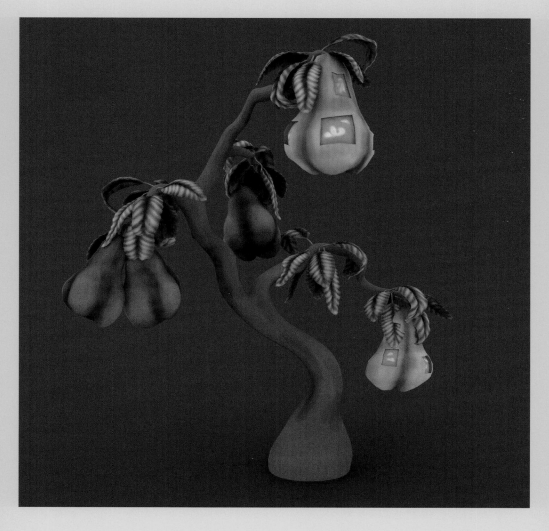

Ventus ingenero

Windmill flower

NAMING CONVENTIONS

Ventus = wind
ingenero = generate

DESCRIPTION

Ventus ingenero is indigenous to the barren windswept plains of the more arid latitudes. It is easily identified by the moving parts of its bright blue flowers. Originally cultivated and still prized for its power-generating capabilities, the *Ventus ingenero* is often found planted in rows surrounding inhabited areas, where it can be used as a power source thanks to its unique "plug-root."

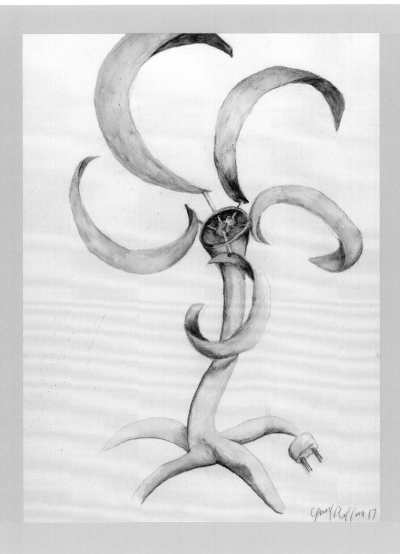

6 ISLAND B

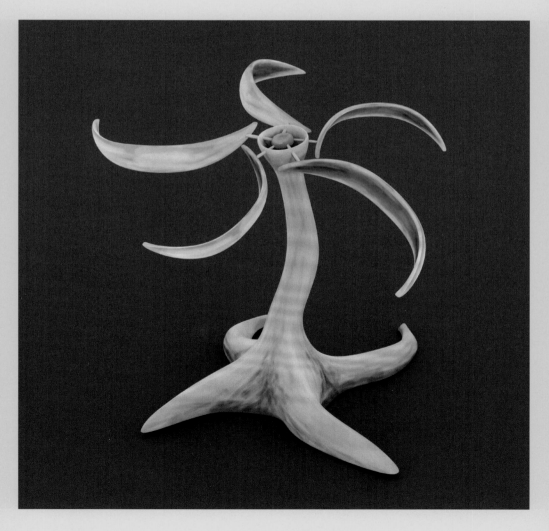

21

Canna grandiflora

Magnolia gondola

NAMING CONVENTIONS

Canna = gondola
grandiflora = magnolia

DESCRIPTION

Canna grandiflora has evolved a unique method of seed dissemination. Due to its aqueous habitat, its large nut-like seeds floated upon falling into the water and most were unable to find enough soil to germinate safely. Over time, a novel solution to this problem evolved. The plant's large boat-shaped blooms were able to transport the seeds to solid earth, where they could bud and grow again.

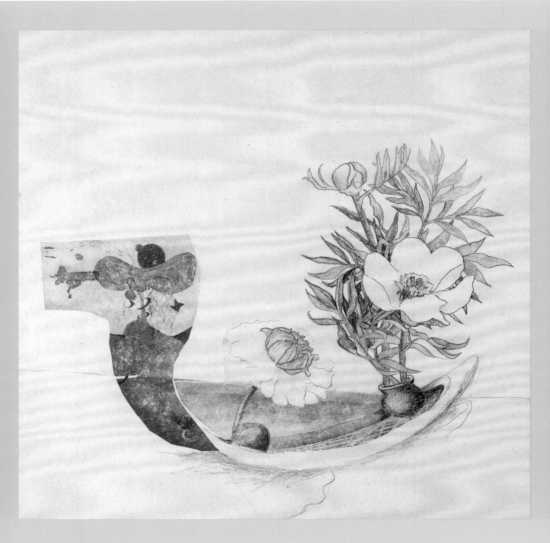

LOCATION

7

ISLAND B

TARGET

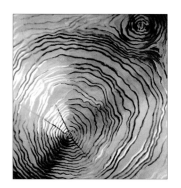

23

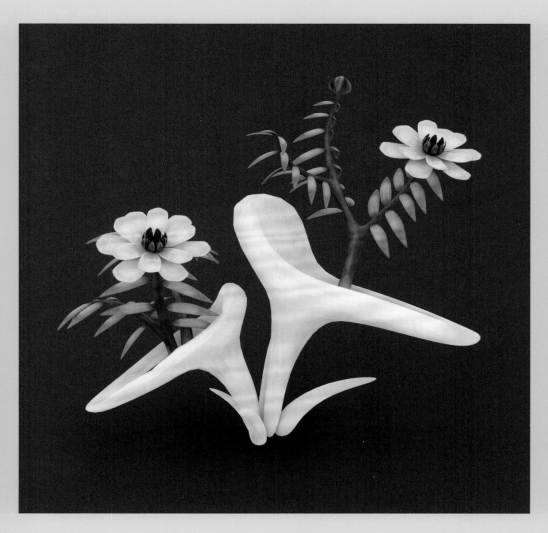

Cibus devoradum

Carnivorous pitcher plant

NAMING CONVENTIONS

Cibus = bait
devoradum = devour

DESCRIPTION

Cibus devoradum was originally found in low-lying boggy areas. This hardy species has a thick fibrous stem that has allowed it to thrive in arid environments. After attracting insect pollinators with its sticky "bait" pistils, it places the trapped prey in its central digestive bath, where they are slowly dissolved. The undigested remains of the exoskeleton are secreted out the waste port on the underside of the bath.

24

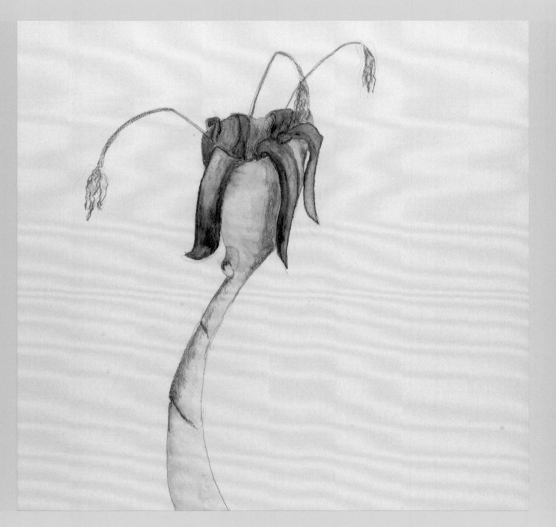

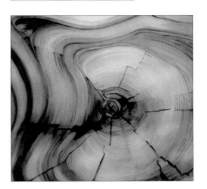

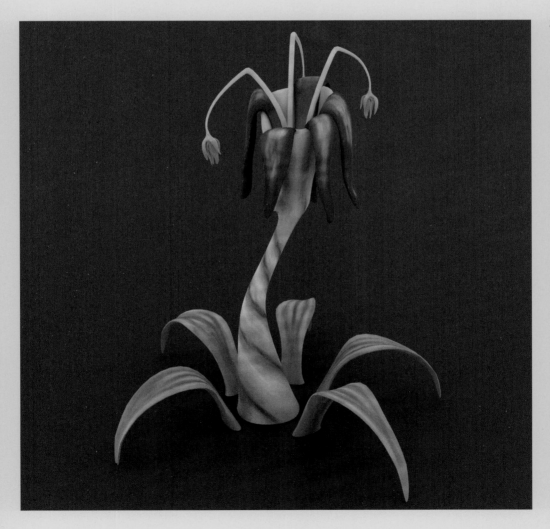

25

Digitalis artherium

Double art flowers

NAMING CONVENTIONS

Digitalis = foxglove
artherium = art

DESCRIPTION

Digitalis artherium is an extremely rare plant that produces a wide variety of brightly colored petal patterns. Formerly abundant in Manhattan, it now grows only under carefully controlled conditions. It has evolved an elaborate series of unusual flower petal patterns to attract human pollinators. It blooms once a month, for one evening. When carefully harvested, dried, powdered, and dissolved in expensive bottled water, its petals can be used as an hallucinogenic.

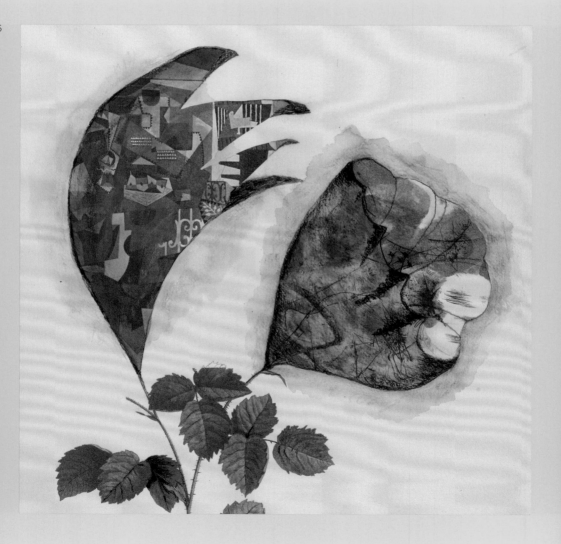

ISLAND C

9

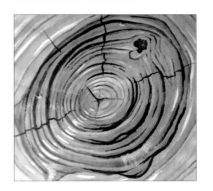

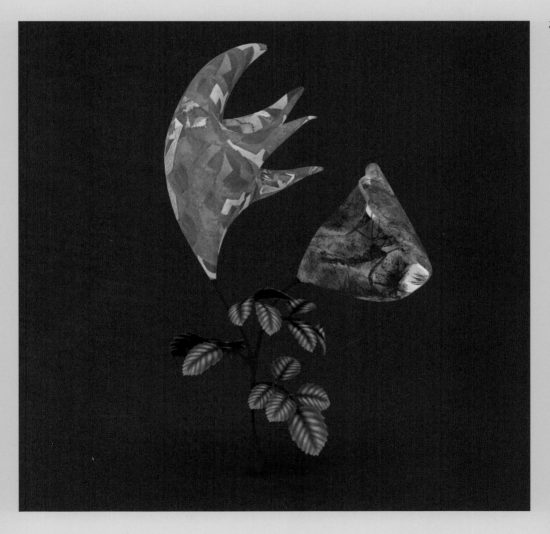

Lacertus vespertilio

Flapping lizard bat flower

NAMING CONVENTIONS

Lacertus = lizard
vespertilio = bat

DESCRIPTION

Lacertus vespertilio is as useful as it is beautiful, and is a favorite of gardeners worldwide. The energetic movement of its foliage is prized both for its striking visual display and for the protection it offers from foraging predators, which is why the plant is so often found in borders around cultivated areas.

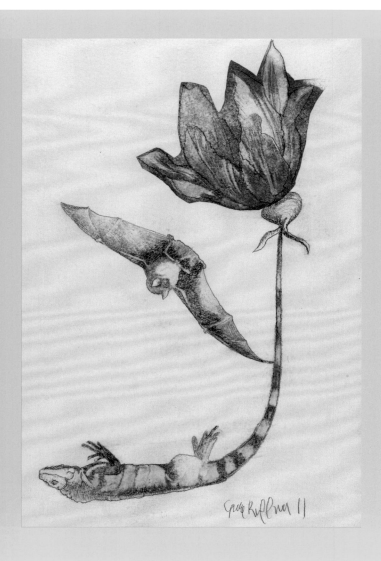

LOCATION

ISLAND C 10

TARGET

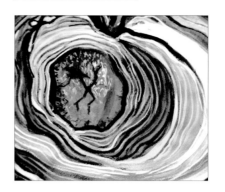

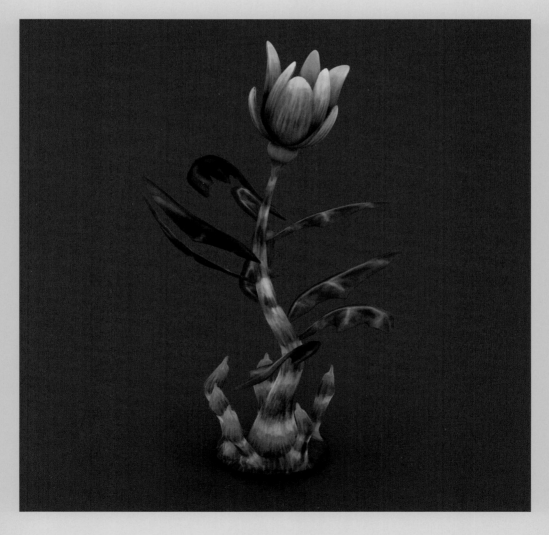

29

Musa saponifica

Soapy muse

NAMING CONVENTIONS

Musa = banana
saponifica = saponify,
to make bubbly

DESCRIPTION

Musa saponifica is found in hot, moist, formerly jungle environments. It is easily identified by the sighing sound it makes as it exhales after inflating its air bladder. The soapy muse (as it is commonly known) evolved this unusual combination of sight and sound signals as a way of attracting human pollinators. Following a series of showy inflations, the bladder bursts, scattering pollen into the air and onto the surrounding surfaces. Human observers inadvertently transport the pollen to other locations on their feet and clothing.

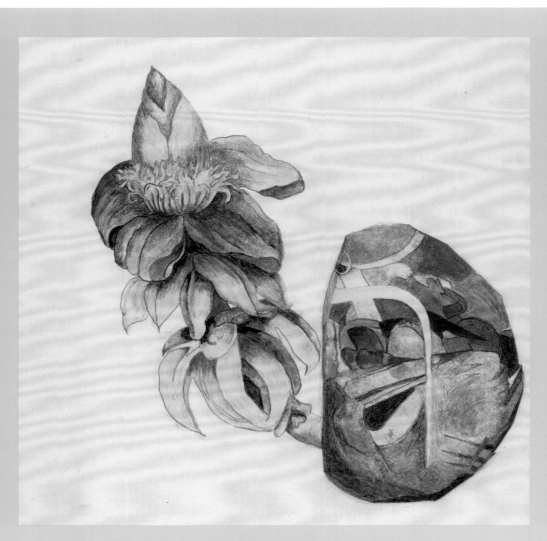

11

ISLAND D

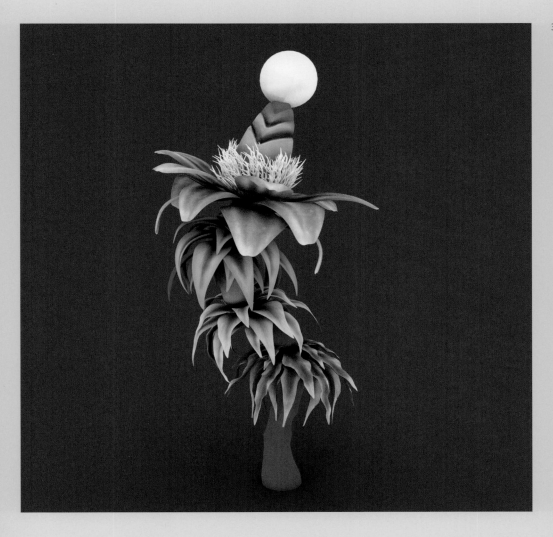

Picus germinabunt

Woodpecker flower

NAMING CONVENTIONS

Picus = woodpecker
germinabunt = blossom

DESCRIPTION

Picus germinabunt is a small but captivating plant, distinguished by its bulbous stem and striped, claw-like roots. Originally propagated via bird droppings containing ingested seeds that were encased in tree sap cast on the ground, the woodpecker flower now employs a more preemptive method of reproduction. After selecting a seed from the storage sac in its stem, it digs a small hole with its claw-like root and, using the beak-shaped central pistil, deposits the seed into the freshly dug opening.

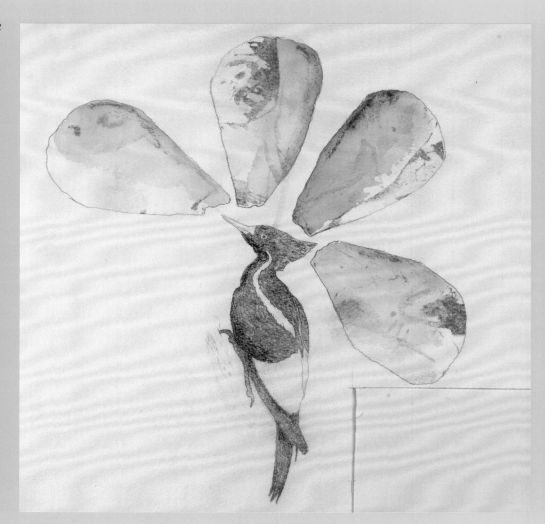

12

ISLAND D

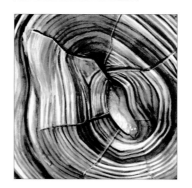

33

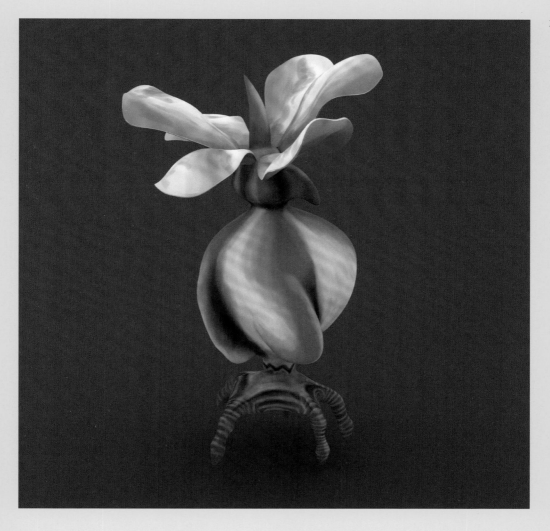

Scandent
vinea clayaria

Morning glory
with Paul Klee leaf

NAMING CONVENTIONS

Scandent = trailing
vinea = vine
clayaria = Paul Klee

DESCRIPTION

Scandent vinea clayaria is a prolific vine that produces a colorful leaf-like blossom on its growing tip. It is typically found in deforested, windy environments where it attracts raptor pollinators by the continual motion of its elaborately patterned bloom, which mimics the activity of a rodent feeding off its succulent roots. The tenacious grip that these roots maintain on the rocky landscape prevents uprooting by overzealous raptors as they search for the prey they have been tricked into believing are feeding underground.

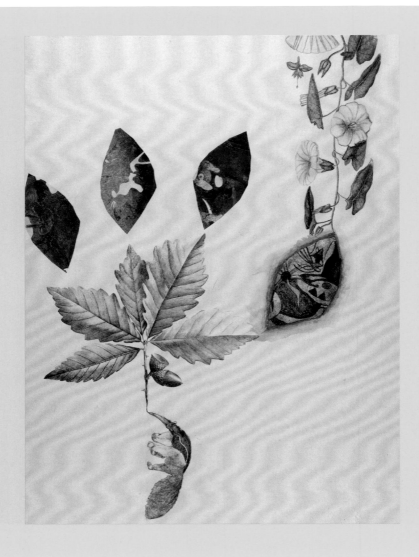

13

ISLAND D

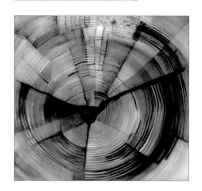

35

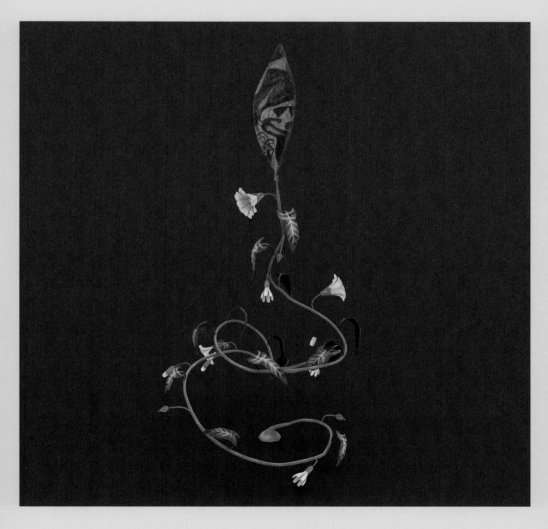

Tulipia kandinskiana torquem

Kandinsky tulip

NAMING CONVENTIONS

Tulipia = tulip,
kandinskiana =
Wassily Kandinsky
torquem = collar

DESCRIPTION

Tulipia kandinskiana torquem is a classic example of mutually beneficial evolution. The tulip-shaped blossom originates in a collar-style organ similar to common sepals. During growth, the bud's surface provides nourishment for a symbiotically parasitic insect, the Afy mite. The mite's strict pattern of consuming the outer layer of the developing flower results in a highly ornamental design on its petals. Obsessively cultivated for generations by humans, the plant, and by extension the mites, would not survive in the wild.

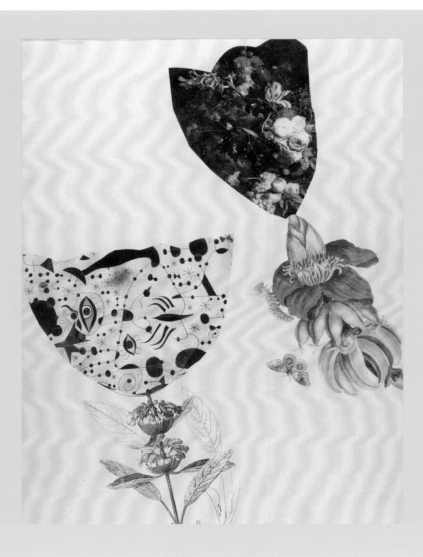

ISLAND D

14

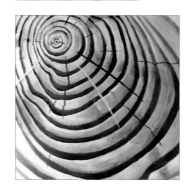

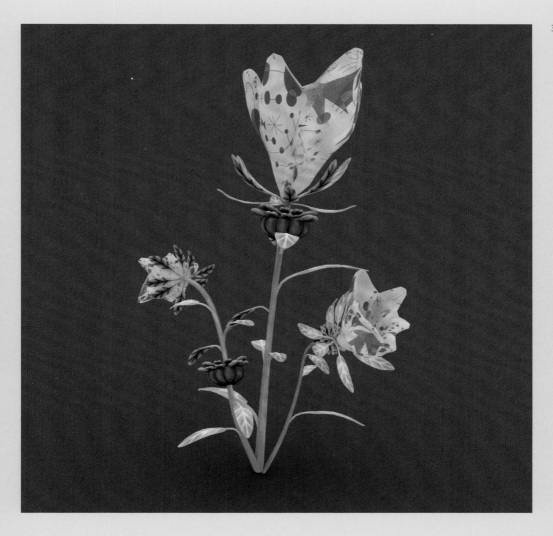

Avem iridis illuricae

Hummingbird flower

NAMING CONVENTIONS

Avem = bird
iridis illuricae = iris

DESCRIPTION

Avem iridis illuricae, exotic and vibrant, is native to formerly subtropical wooded areas. Facing extinction due to a shortage of other pollinators, it creatively adapted by providing its major pollinator, the two-toned hummingbird, with a protected nest within its blossom. The nest entry opens and closes in response to the presence of that particular species.

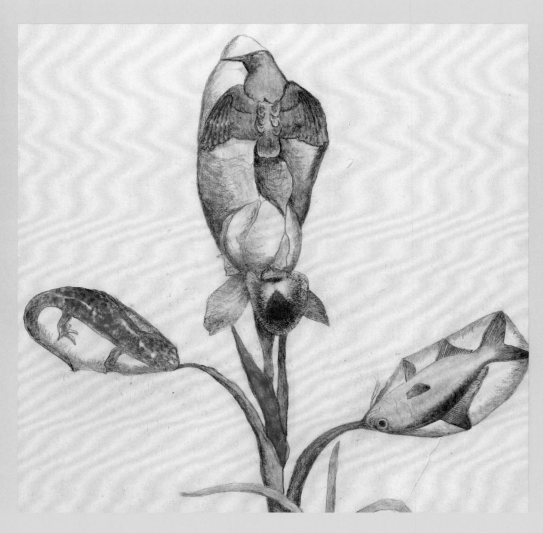

15

ISLAND E

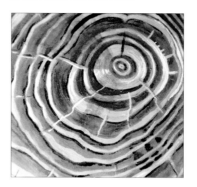

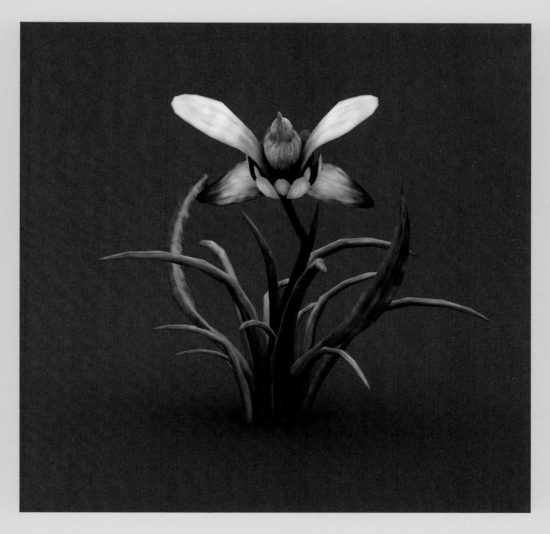

Astromaria
zentada lillium

Blue/purple flowering vine

NAMING CONVENTIONS

zentada = yin/yang,
lillium = lily

DESCRIPTION

Astromaria zentada lillium is found in high-altitude mountainous locales where it blooms morning and evening in the spring. The bright blue petal tops and the deep violet undersides provide a diurnal/nocturnal camouflage that protects against predators. The unpleasant taste and texture of its woody stem also discourages hungry herbivores. When its extravagant petals become completely unfurled, the *Astromaria*'s hidden seeds are fully exposed and scattered by the wind.

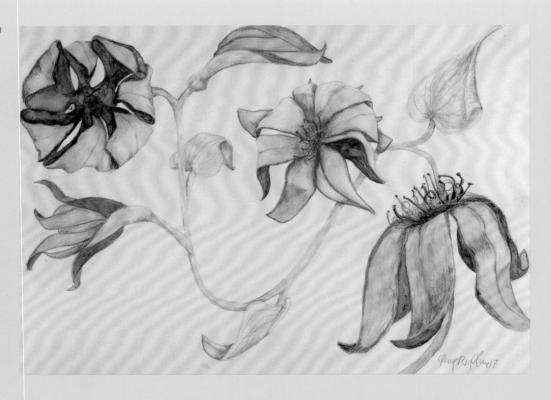

16
ISLAND E

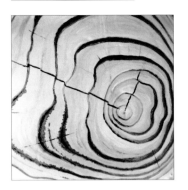

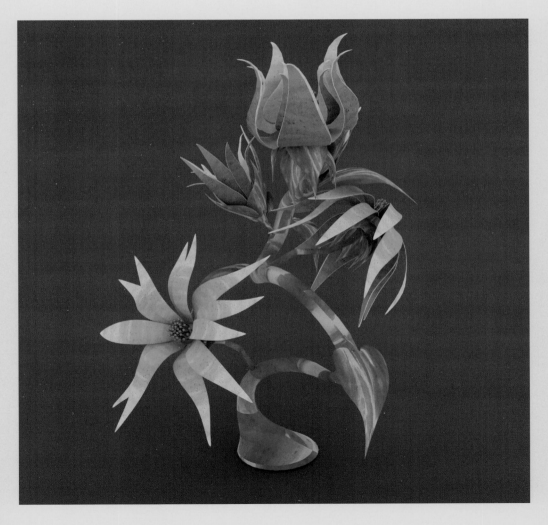

Navis tabula senex

Connect the dots flower

NAMING CONVENTIONS

Navis = boat
tabula = map
senex = old

DESCRIPTION

Navis tabula senex is descended from an ancient tuberous succulent. This nomadic species can be found in a multitude of environments due to its unusual locomotive ability. Originally found solely on the edges of bodies of water, the plant gradually developed appendages, which allowed it to relocate and colonize drier habitats. The succulent stem allows it to transport water as needed.

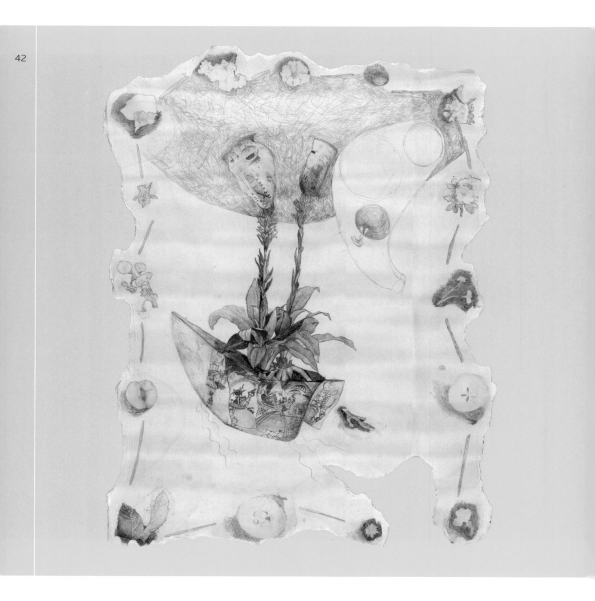

ISLAND E

17

43

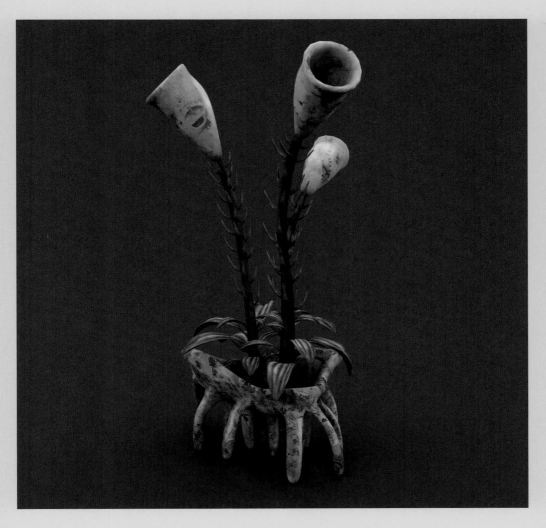

Rosa cilliabunda

Rose with eyelashes

NAMING CONVENTIONS

Rosa = rose
cilliabunda = lots of cilia

DESCRIPTION

Rosa cilliabunda, native to the middle latitudes, has evolved a highly unusual method of pest control to protect its delicious buds: curly, thistle-like thorns cover the stalk and the buds, thus limiting foraging by predators.

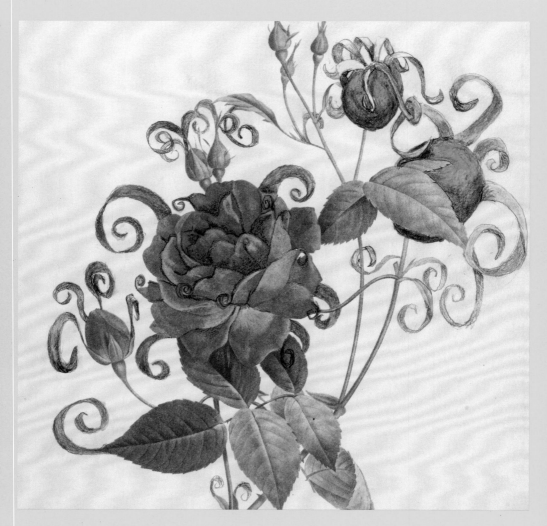

ISLAND E

18

45

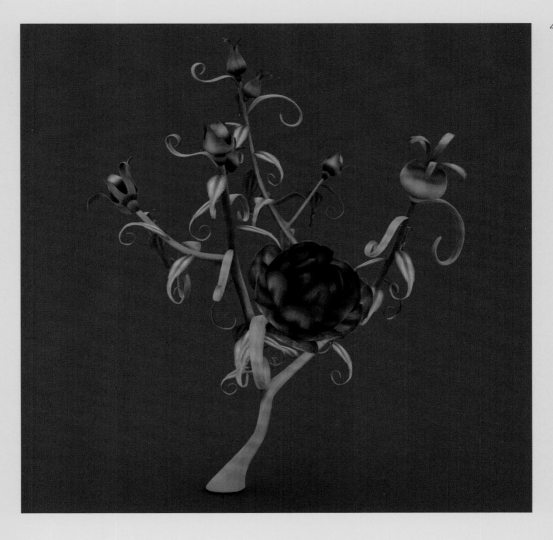

An Interview with the Artist

A passionate believer in art as a social necessity, and no stranger to challenges, Ginny Ruffner spoke with Nora Atkinson, the Lloyd Herman Curator of Craft at the Renwick Gallery, in the fall of 2018 to discuss her art, the relationship between science and nature, and how we define beauty.

This interview was edited for length and clarity.

NORA ATKINSON: You were born in Atlanta, Georgia, and spent most of your young adulthood in the South, then you relocated to Seattle in the early 1980s. Tell me about that move. How did living in the Pacific Northwest and teaching at the Pilchuck Glass School [in Stanwood, WA] influence your work?

GINNY RUFFNER: I consider moving to Seattle one of the best things I've done in my life. The open and supportive nature of both Seattle and Pilchuck allowed me to continue to experiment in my art.

NA: How did you come to be associated with the Pilchuck Glass School, and what was your experience like there?

GR: I was invited to teach. I loved the area, so I moved there. Pilchuck was fun and inspiring, a good combination.

NA: In 1991 you were involved in a car accident, which left you in a coma. You might have quit working at that time, yet remarkably, it barely seems to have slowed you down. In what ways, if any, did your work change after your accident?

GR: That accident provided an undeniable opportunity to reassess everything, especially since I was unable to do anything at first.

I forced myself to draw daily, even though I could barely hold a pencil and had to use my nondominant hand. Those drawings were monumentally, poignantly awful. But creating something, anything, helped me remember who I was.

As soon as I got out of the hospital, I began to create glass sculpture again, working with assistants. In the beginning, those glass sculptures were smaller, so that I could interact with them more easily. As I improved, the work got larger.

Conceptually, the earliest postaccident series was about balance, the literal type of balance that is required to learn to walk, as well as the personal type of balance required to live

life. In hindsight I've realized that my work has always been about my life—inner and outer— so, yes, before the accident I was doing/making exactly what I needed to be making. Continuing to evolve from that point was the truest way to proceed. I try to do that now. If anything, that accident amplified my persistence, and reaffirmed my belief in the critical importance of creating.

NA: Your prior series, *Aesthetic Engineering: The Imagination Cycle* (2007), features larger-than-life twisted metal bases, out of which spring magical, exuberant flowers. This current project [*Reforestation of the Imagination*], seems to carry a similar theme—a barren landscape, alongside which an imaginative world is thriving, unseen to the naked eye. Is there a metaphor there?

GR: Yes, but this is absolutely not about the accident. Maybe about persistence, but not about any tragedy. To me this project [*Reforestation*] is about hope.

NA: How did you first become aware of and involved in augmented reality (AR)? It's not something many people work with. Was it daunting to wrap your head around work in such a cutting-edge medium?

48 GR: In 2014, I was invited to see a new technology being developed in order that I might advise how an artist might be able to use that technology. That technology was early AR. I was amazed and intrigued. I was again seduced by potential. I found an AR/VR class at a local art school to audit and began to learn how to do it. Grant Kirkpatrick was also auditing the same class. After a short while, we began to work on the early stages of *Reforestation of the Imagination*.

Yes, learning AR was the most difficult thing I've tried to learn. But I love a challenge. And I remain highly motivated to make art using this fabulous medium.

NA: What is it about science and nature—and in particular, genetic hybridization—that inspires you? What is it about flowers?

GR: Genetic hybridization inspires me because it is a scientific means of achieving the same goals as art—the creation of something new and unexpected from current reality.

Why flowers? Before the accident, I was working on a long-running series about beauty. Flowers are a direct evolution from that series. Because they are one of the few things in the world that are universally (both culturally and throughout time) considered beautiful, flowers are a powerful icon. Flowers are paradoxically both temporary and fragile as well as eternally beautiful. When the viewer encounters these imaginarily evolved beautiful flowers [in *Reforestation*], hopefully they are provoked to wonder about how beauty might evolve.

NA: Throughout your career, you've been known for your experimentation, incorporating paint, metal, and other materials into your glass pieces. What kind of impact do you think this has on your work, and why did you decide to differentiate yourself from other glass artists in this way?

GR: I absolutely do not consider myself a "glass artist." I am an artist. As you point out, glass is just one of the media I use. I utilize whatever media seem most expressive for the particular idea I'm trying to convey.

NA: Do you prefer working in one format or medium over the others?

GR: I enjoy every format. Each is a tool. They each bring their own unique expression.

*"Beauty's role in my art
is to invite the viewer to think."*

NA: Tell me about how you started using the lampworking technique. What drew you to lamp-working?* How does it allow you to create your desired forms?

GR: When I first encountered lampwork, in 1976, I was struck with its potential. Because its physical capabilities were/are so flexible, I felt it would be an excellent medium to continue my efforts to get more light into my paintings. Then I had to learn how to do it. I embarked on a five-year lampworking apprenticeship.

NA: Was that at Pilchuck? With whom did you apprentice?

GR: No, I *taught* the first borosilicate lampworking class at Pilchuck, in 1984. I was never a student, but I did teach seven times at Pilchuck.

The first year that I taught, 1983, at Penland School of Craft in North Carolina, I brought all the torches and tools. The next year, 1984, I did the same at Pilchuck. In 1985, I did the same at the Pratt Fine Arts Center in Seattle. At all three schools I taught the first lampworking class.

I apprenticed with Hans Godo Frabel in Atlanta.

NA: What are your thoughts about the concept of beauty as it applies to art/craft?

GR: Beauty doesn't care where it exists or the definition of that place.

NA: Can you expand on that? As you've mentioned, beauty has been central to your work for many years.

GR: The concept of beauty has intrigued me for a long time. We all know "beauty," yet we can only define it through its objectification.

Beauty has been valued throughout time and in every culture. Beauty is extremely subjective. I think that beauty is parallel to art in its meaning/ definition: a bit inexplicable, very subjectively defined, yet desirable and precious. Beauty's role in my art is to invite the viewer to think.

NA: With the speed of technology these days and its effect on every part of our lives, it's a particularly interesting time to be alive as an artist. How do you think interactive technology, not only AR and VR but also Instagram and social media, is changing art and our experience of it?

"… I am fully optimistic about the power of the imagination to solve any problem."

50

GR: Interactive technologies provide a means for the viewer to participate in creation. That empowerment is thrilling and a bit addictive. The same rewards drive social media, which explains the near-universal success of social media.

NA: Your website describes your "rejection of irony, pretension, and the high- and lowbrow dichotomy." Can you please explain why you've dismissed these terms, and how this is manifested in your work?

GR: Those labels are all subjective and as such bear examination. I prefer to make my own decisions.

NA: You have said that you started painting on glass after seeing Marcel Duchamp's work *The Bride Stripped Bare by Her Bachelors, Even* [also known as *The Large Glass*; 1915–23]. What about this work inspired you?

GR: The many layers of meaning and the multiple points of entry to appreciate this amazing work. It exists with equal forcefulness in both the intellectual and visual realms.

NA: Are there any other artists or art-historical movements that have influenced your work?

GR: Kandinsky, Klee, Picasso.

NA: Many of your works, including the flowers you invented for *Reforestation of the Imagination*, are clever and often humorous, as are your titles for them. Where does this visual and linguistic playfulness come from?

GR: I read a lot. And I find life in general pretty amusing. I think wordplay is the highest form of humor. It denigrates no one, and it requires a certain amount of linguistic skill to pull it off.

NA: And how do you think it adds to the viewer's experience of your pieces?

GR: My highest hope for all of my work has always been to make the viewer think.

NA: Are you, as *Reforestation* seems to suggest, optimistic about the state of our environment and its ability to rebound, as well as our use of technology for good rather than evil?

GR: I'm not so optimistic about the state of our environment—however, I *am* fully optimistic about the power of the imagination to solve any problem. It just requires looking at the problem in a different way. I'm not suggesting denial. At all. Quite the contrary. As for technology— good and evil are very subjective labels.

I do not like being told what to think, nor do I like telling people what to think. I prefer to point out facts and let them draw their own conclusions. That being said, I try to not miss any opportunity to encourage thinking.

NA: Many of your works are collaborations, and you have expressed your belief that most art is more or less collaborative. Why do you think people continue to uphold the myth of the artist as a solo "genius"?

GR: It's easy, it's masculine (which has been the dominant stance in our culture), and individualism is prized in most Western societies. Actually, most people don't understand the art-making process, either.

NA: Your works often contain various references and symbols, and you seem to embed little "jewels" in your descriptions and imagery that reward close examination. Do you intend for

these pieces to have specific meanings that can be deciphered by the viewer if they spend enough time looking at and thinking about them?

GR: No, I want the viewer to come up with their own interpretation, to reach their own conclusion. I really want to invite the viewer to think, so I try to provide "thought bait."

In lampworking, an artist uses a torch or hot flame to melt the glass. The molten glass is then blown and shaped with various tools and hand movements.

Checklist of Works

All sculptures and drawings are by Ginny Ruffner, and dated 2017.
Dimensions are given in inches; height precedes width and depth.

DRAWINGS

52 All drawings are watercolor,
pencil, and image transfer on
paper unless otherwise noted.
Dimensions are overall:
image and sheet.

Anthurium vinifera
(Grape flower)
18 ½ × 14 ¼ in.
p. 12

Astromaria zentada lillium
(Blue/purple flowering vine)
17 ½ × 23 in.
p. 40

Avem iridis illuricae
(Hummingbird flower)
21 × 16 in.
p. 38

Bronze Tree
(center island)
watercolor and pencils on paper
23 × 17 ½ in.
(not illustrated)

Canna grandiflora
(Magnolia gondola)
21 × 27 in.
p. 22

Cibus devoradum
(Carnivorous pitcher plant)
23 × 17 ¼ in.
p. 24

Digitalis artherium
(Double art flowers)
26 × 18 ½ in.
p. 26

Lacertus vespertilio
(Flapping lizard bat flower)
13 × 9 in.
p. 28

Liriodendrum plausus
(Flapping tulip)
12 × 12 in.
p. 10

Musa saponifica
(Soapy muse)
23 ½ × 17 in.
p. 30

Navis tabula senex
(Connect the dots flower)
26 × 20 ½ in.
p. 42

Picus germinabunt
(Woodpecker flower)
18 ½ × 21 ¼ in.
p. 32

Pyrus fenestrata
(Pear with windows)
18 ½ × 14 ½ in.
p. 18

Rosa cilliabunda
(Rose with eyelashes)
18 ¼ × 14 ¼ in.
p. 44

Serpens primula nubes
(Blue flower with snakes)
27 × 21 in.
p. 16

Scandent vinea clayaria
(Morning glory with Paul
Klee leaf)
23 ½ × 17 in.
p. 34

Taraxacum genu varum
(Dandelion carrot)
23 ½ × 17 in.
p. 14

Tulipia kandinskiana torquem
(Kandinsky tulip)
23 ½ × 17 in.
p. 36

Ventus ingenero
(Windmill flower)
23 × 17 ½ in.
p. 20

Opposite:
Detail, *Digitalis artherium*
(Double art flowers); see p. 26.

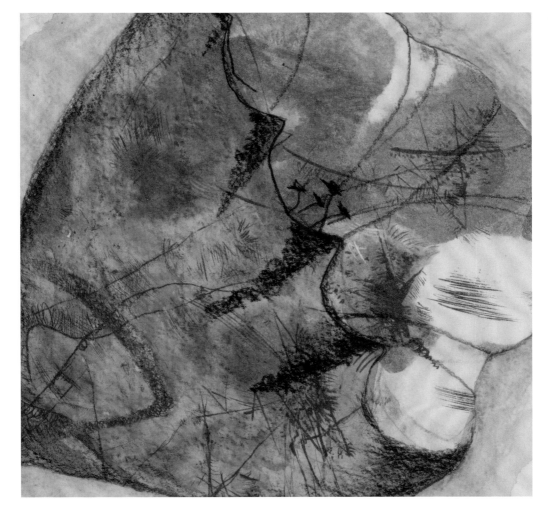

SCULPTURES

54 All tree stump sculptures are handblown glass with acrylic paint tree rings unless otherwise noted. Only the target portions of sculptures are illustrated in the field guide.

Anthurium vinifera
(Grape flower)
13 ½ × 9 × 5 ½ in.
p. 13

Astromaria zentada lillium
(Blue/purple flowering vine)
12 × 16 × 15 in.
p. 41

Avem iridis illuricae
(Hummingbird flower)
15 × 12 × 6 ½ in.
p. 39

Bronze Tree
(center island)
plywood, low-density foam, fiberglass, epoxy, sand, pebbles, acrylic paint, bronze, and lampworked glass
overall: 50 × 63 × 49 in.
(not illustrated)

Canna grandiflora
(Magnolia gondola)
13 ¼ × 13 × 11 ½ in.
p. 23

Cibus devoradum
(Carnivorous pitcher plant)
12 × 14 × 15 in.
p. 25

Digitalis artherium
(Double art flowers)
9 × 13 × 11 ½ in.
p. 27

Lacertus vespertilio
(Flapping lizard bat flower)
18 × 10 ½ × 8 ½ in.
p. 29

Liriodendrum plausus
(Flapping tulip)
19 × 12 × 9 in.
p. 11

Musa saponifica
(Soapy muse)
9 × 9 × 9 in.
p. 31

Navis tabula senex
(Connect the dots flower)
9 × 11 × 13 ½ in.
p. 43

Picus germinabunt
(Woodpecker flower)
7 ½ × 12 × 10 ½ in.
p. 33

Pyrus fenestrata
(Pear with windows)
10 × 11 × 12 in.
p. 19

Rosa cilliabunda
(Rose with eyelashes)
9 × 21 × 14 in.
p.45

Scandent vinea clayaria
(Morning glory with Paul Klee leaf)
9 ½ × 10 ½ × 10 ½ in.
p. 35

Serpens primula nubes
(Blue flower with snakes)
9 × 10 × 10 in.
p. 17

Taraxacum genu varum
(Dandelion carrot)
7 ½ × 19 ½ × 13 ½ in.
p. 15

Tulipia kandinskiana torquem
(Kandinsky tulip)
18 ½ × 13 × 14 in.
p. 37

Ventus ingenero
(Windmill flower)
14 × 12 × 7 in.
p. 21

Ginny Ruffner: Reforestation of the Imagination
by Ginny Ruffner, with Grant Kirkpatrick

Published in conjunction with the installation
Ginny Ruffner: Reforestation of the Imagination on
view at the Renwick Gallery of the Smithsonian
American Art Museum, Washington, DC, June 28,
2019, through January 5, 2020.

Ginny Ruffner: Reforestation of the Imagination
was fabricated by Ruffner Studio with the support
of MadArt, Seattle. It was first exhibited at MadArt
Studio in 2018.

All artworks and images courtesy of Ruffner Studio.
Photographs of drawings by Eugene Young.

Cataloging-in-Publication Data available at the
Library of Congress, loc.gov, LCCN 2019021117.

ISBN 978-0-937311-86-8

Second printing, 2021

10 9 8 7 6 5 4 3 2

Published by the Publications Office, Smithsonian
American Art Museum, Washington, DC

Robyn Kennedy, *Project coordinator*
Elana Hain, *Curatorial assistant*

Theresa J. Slowik, *Chief of Publications*
Mary J. Cleary, *Editor*
Aubrey Vinson, *Permissions and images coordinator*
Eugene Young, *Photographer*

Designed by Antonio Alcalá, Studio A
www.studioa.com

Visit us at AmericanArt.si.edu

SAAM Renwick

BECAUSE OF
HER
STORY

 Smithsonian

Cover: Detail of tree ring (AR target) for
Taraxacum genu varum (Dandelion carrot), 2017,
acrylic paint on handblown glass; see pp. 14–15.

Frontispiece: Detail, *Canna grandiflora*
(Magnolia gondola), 2017, watercolor, pencil,
and image transfer on paper; see p. 22.